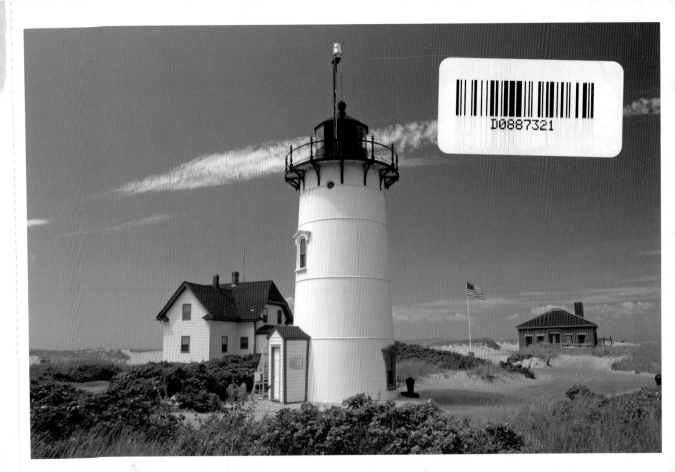

Race Point Lighthouse, Provincetown, Massachusetts, established 1816. This cast iron tower, built in 1876, stands at the tip of Cape Cod. Automated in 1978, it includes a keeper's house and marine science center.

Published by schifferbooks.com

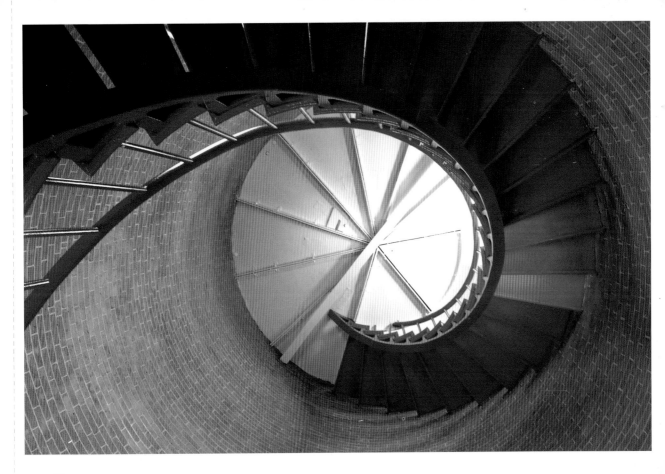

Race Point Lighthouse stairs. Built in 1876, 45 steps lead to the lantern room. Tours are available of the lighthouse and grounds.

Published by schifferbooks.com

© 2006 Arthur P. Richmond

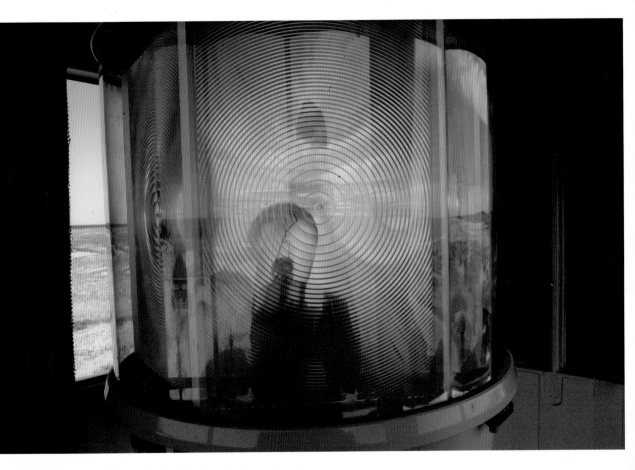

Race Point Lighthouse aero beacon. The aero beacon has replaced the oil lamps and Fresnel lenses. Note the blacked out sections that limit the beam of the light.

Published by schifferbooks.com

© 2006 Arthur P. Richmond

Race Point keeper's house yellow
bedroom. Totally renovated, the keeper's
house has three bedrooms available to
the public. They can be reserved from
mid-May to mid-October.

© 2006 Arthur P. Richmond

Published by schifferbooks.com

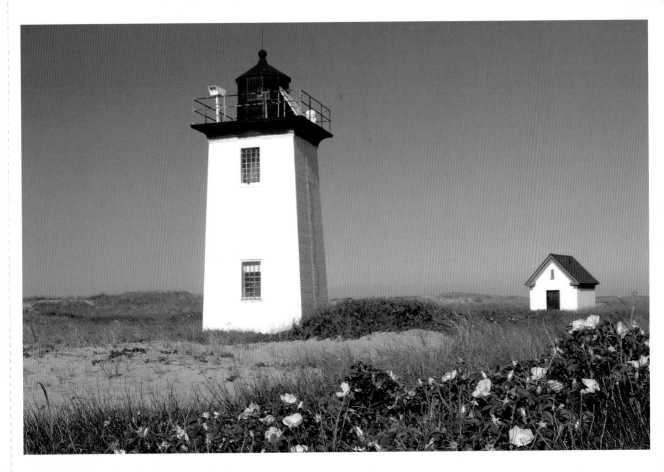

Wood End Light, Provincetown,
Massachusetts, established 1864.
Automated in 1961 and now solar
powered, only the light and oil storage
building remain from what was once
the Wood End Life Saving Station.

Published by schifferbooks.com

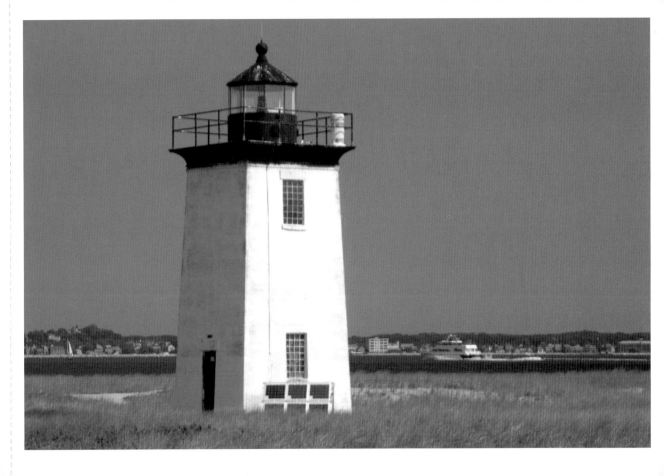

Long Point Light, Provincetown,
Massachusetts, established 1826.
Located at the very tip of Cape Cod, the
38 foot brick tower was built in 1875.
Automated in 1952, it is now solar
powered.

Published by schifferbooks.com

© 2006 Arthur P. Richmond

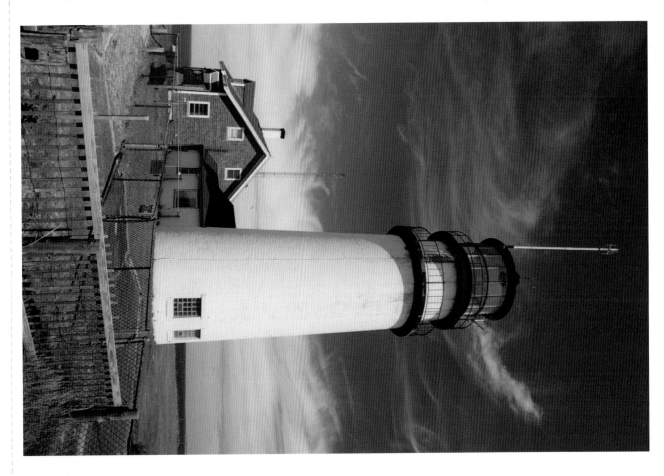

Highland (Cape Cod Light) Light, Truro,
Massachusetts, established 1797. This is
the first and tallest lighthouse on Cape
Cod and is shown in its original location.
It was moved to a new location in 1996.

Published by schifferbooks com

© 2006 Arthur P. Richmond

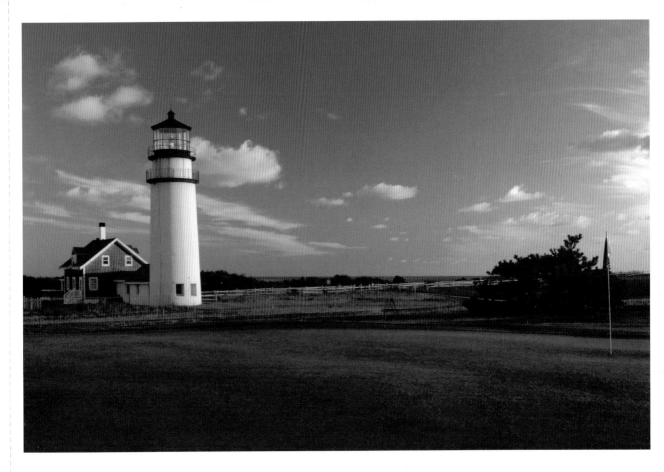

Highland Light, Truro, Massachusetts,
established 1797. After volunteers raised
money to move the light in 1996 to its
present location, it is now surrounded by
the popular Highland Links golf course.

Published by schifferbooks.com

© 2006 Arthur P. Richmond

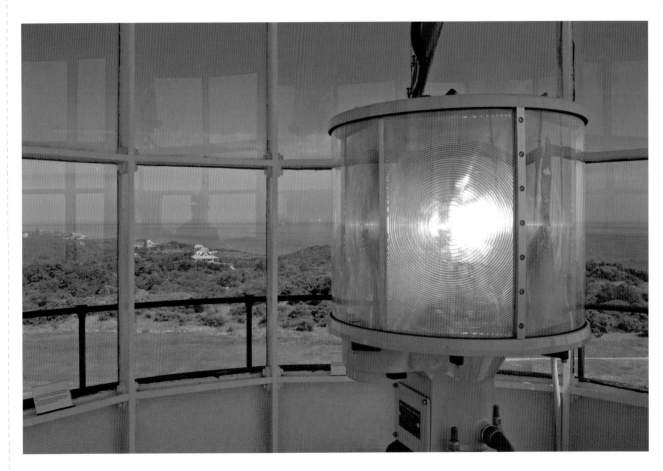

Highland Light aero beacon, Truro,
Massachusetts. The first-order Fresnel
lens, now on display at a local museum,
has been replaced by an aero beacon.
Tours are available.

© 2006 Arthur P. Richmond

Published by schifferbooks.com

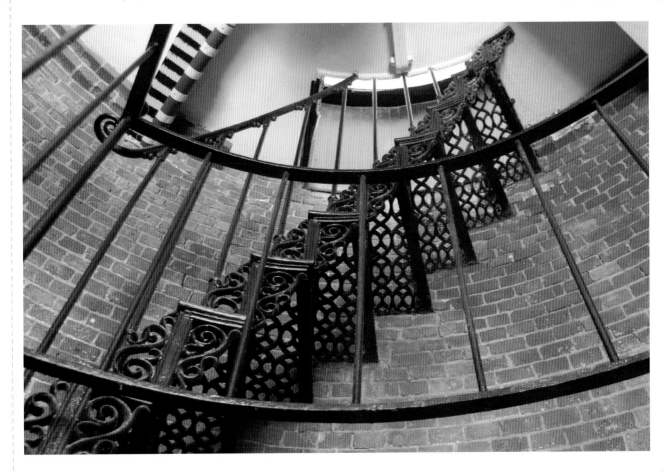

Highland Light stairs, Truro, Massachusetts. Sixty-nine winding stairs lead to the lantern room where visitors can see panoramic views of the Cape from 183 feet.

© 2006 Arthur P. Richmond

Published by schifferbooks.com

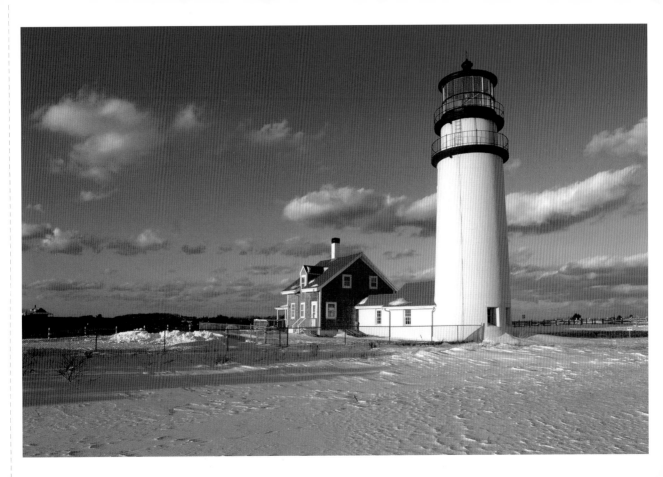

Highland Light, Truro,
Massachusetts, established
1797. Shown here with the
gift shop, which serves as
the entrance to the tower
and the start of the tour.

Published by schifferbooks.com

© 2006 Arthur P. Richmond

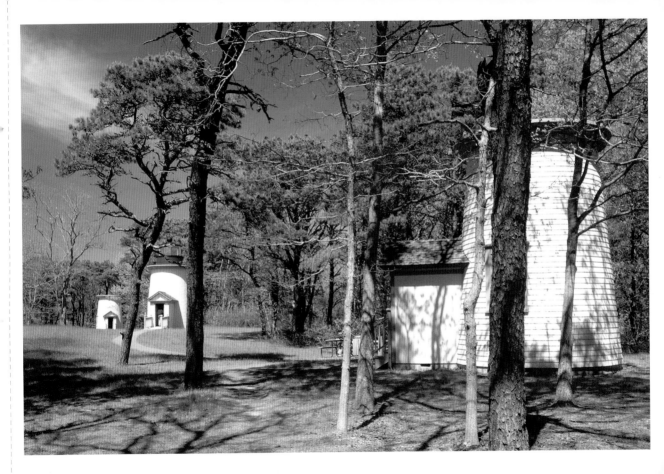

Three Sisters, North Eastham, Massachusetts, established 1838. Located a short walk from Nauset light, the original three lights were replaced by a 48 foot cast iron tower in 1923. The replicas are on display and open for tours.

Published by schifferbooks.com

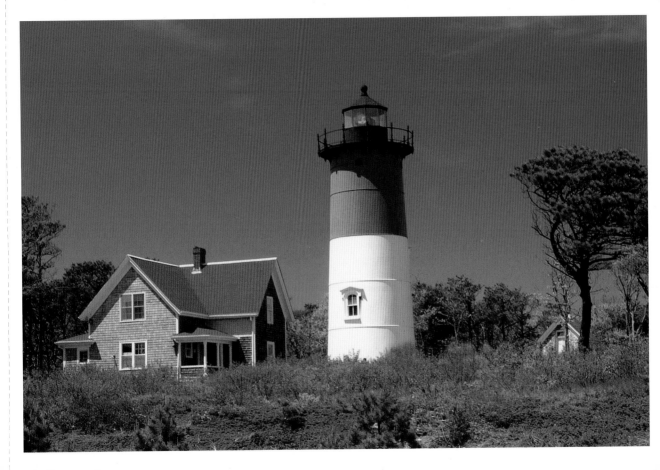

Nauset Light, North Eastham,
Massachusetts, established 1838.
Originally three separate lights,
Nauset Light is now a distinctive red-
over-white tower with alternating red
and white beams. Open for tours.

Published by schifferbooks.com

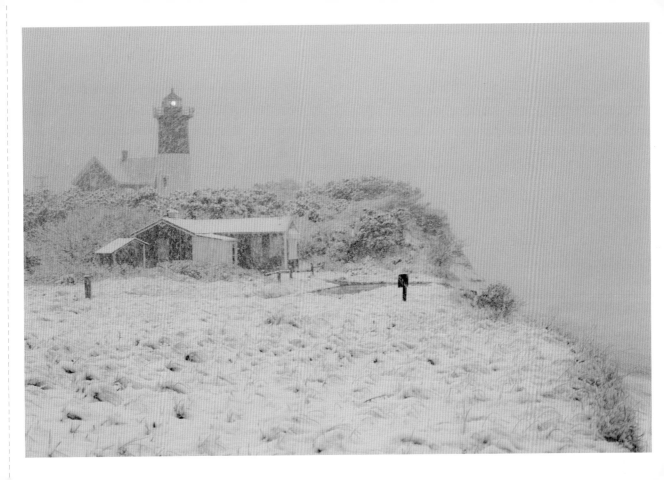

Nauset Light, North Eastham, Massachusetts, established 1838. Seen in its original location, the light was moved back from the eroding cliffs in November 1996.

© 2006 Arthur P. Richmond

Published by schifferbooks.com

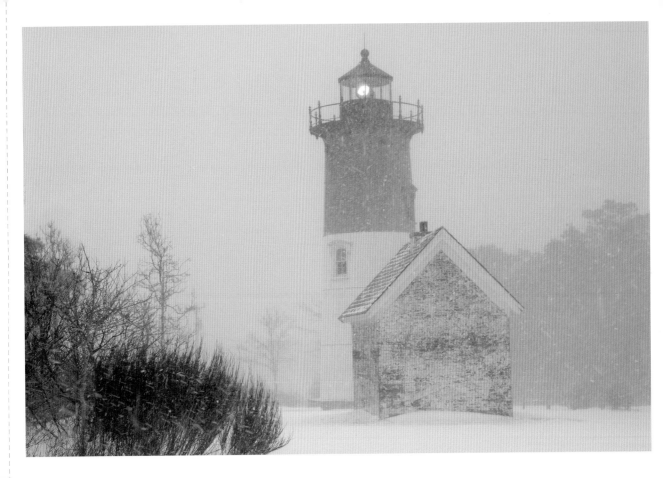

Nauset Light North Eastham,
Massachusetts, established 1838.
Light with oil storage building.

Published by schifferbooks.com

© 2006 Arthur P. Richmond

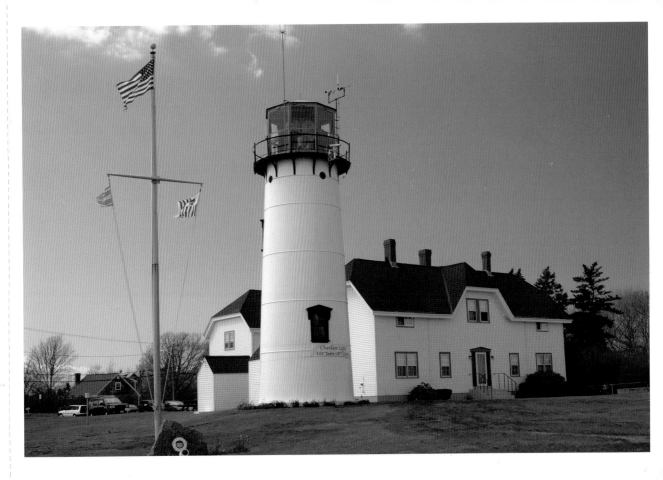

Chatham Light, Chatham, Massachusetts, established 1808. Originally two towers, in 1923 one tower was moved and became Nauset Light. An active Coast Guard Station, the light is open for tours.

© 2006 Arthur P. Richmond

Published by schifferbooks.com

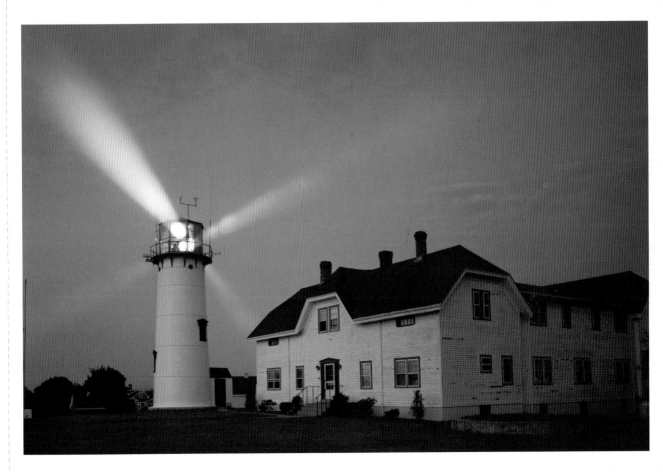

Chatham Light, Chatham, Massachusetts, established 1808. On foggy nights, the two distinctive beams help identify this light.

© 2006 Arthur P. Richmond

Published by schifferbooks.com

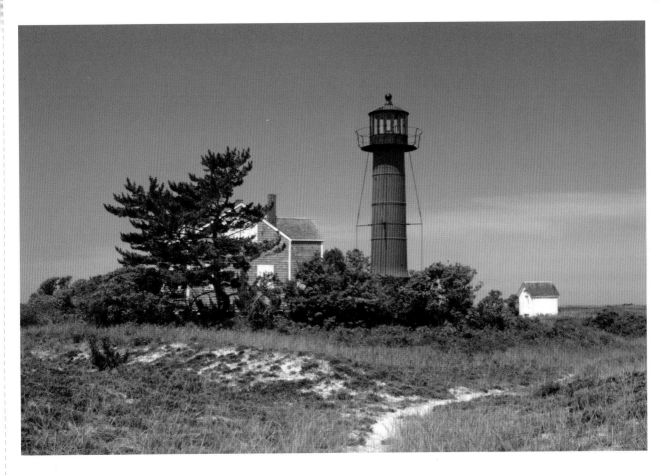

Monomoy Light, Monomoy Island,
Chatham, Massachusetts, established
1823, deactivated 1923. Built to guide
ships around Cape Cod, Monomoy Light
was no longer needed after construction
of the Cape Cod Canal.

© 2006 Arthur P. Richmond

Published by schifferbooks.com

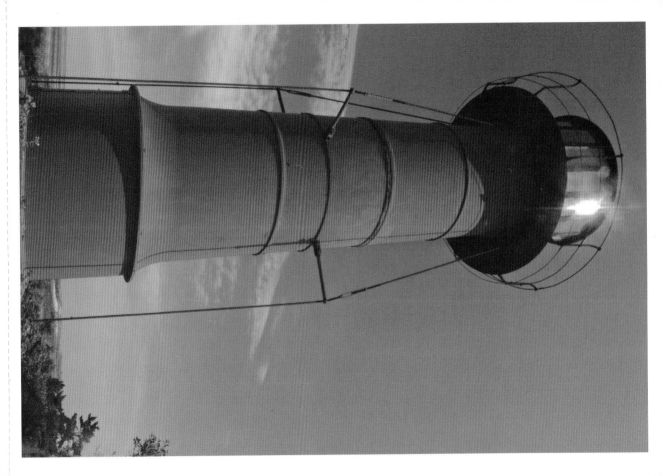

Monomoy Light tower, Monomoy Island,
Chatham, Massachusetts. Built in 1849,
this was one of the earliest cast iron
towers and at only 34 feet was painted
red in 1004 for better visibility.

Published by schifferbooks.com

© 2006 Arthur P. Richmond

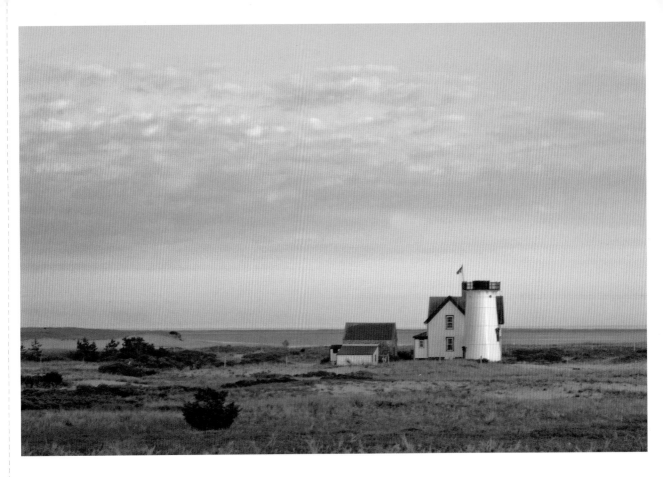

Stage Harbor Light, Chatham,
Massachusetts, established 1880,
deactivated 1933. Originally built to
guide ships into Stage Harbor, it
was replaced by a steel tower and
is now privately owned.

© 2006 Arthur P. Richmond

Published by schifferbooks.com

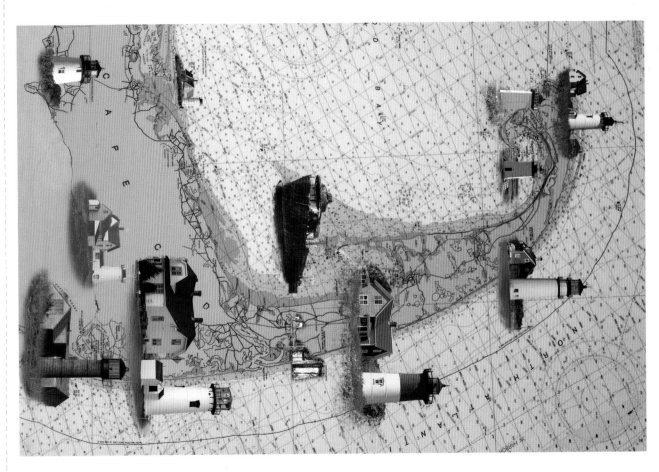

Outer Cape Lights: from top to bottom, left to right, Race Point, Wood End, Long Point, Highland Light, Nauset Light, target ship, Three Sisters, Sandy Neck Light, Chatham Light, Hyannis Light, Stage Harbor Light, and Monomoy Light.

© 2006 Arthur P. Richmond

Published by schifferbooks.com

Bass River Light, West Dennis, Massa-
chusetts, established 1855, deactivated
1914. Originally built to guide ships
along southern Cape Cod, it was no
longer needed after construction of the
Cape Cod Canal. It is now privately
owned and part of the Lighthouse Inn.

Published by schifferbooks.com

© 2006 Arthur P. Richmond

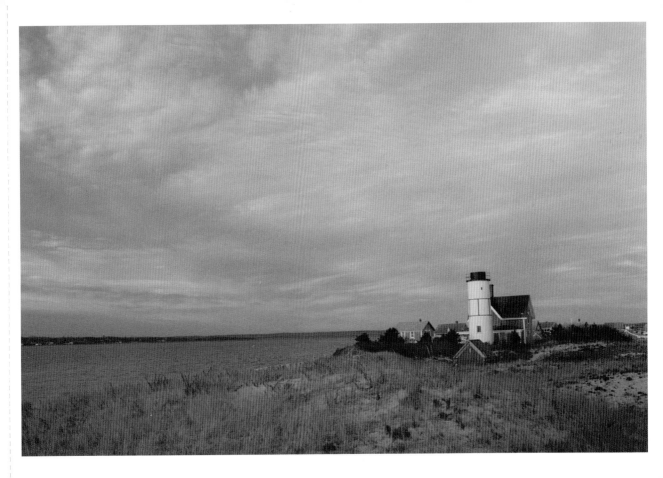

Sandy Neck Light, Barnstable, Massachu-
setts, established 1827, deactivated 1931.
Built to guide ships into Barnstable
Harbor, the 34 foot tower and keeper's
house became non-functional when the
sands and bars moved further east.

© 2006 Arthur P. Richmond

Published by schifferbooks.com

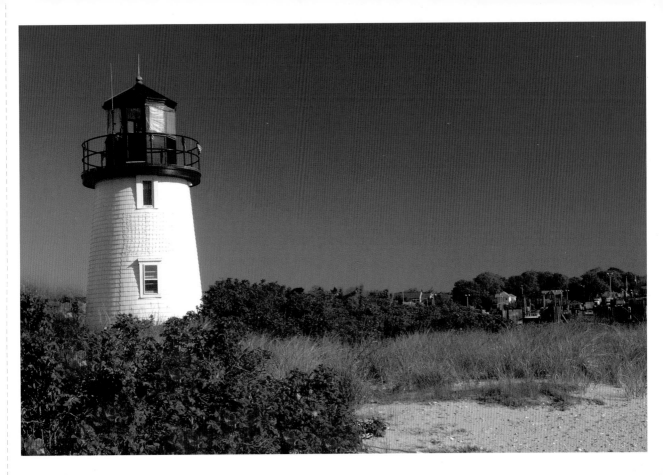

Hyannis Harbor Light, Hyannis,
Massachusetts. Privately owned, this
light was moved to this location from
north of Boston and is now part of a
residence. It is not an aid to navigation.

© 2006 Arthur P. Richmond

Published by schifferbooks.com

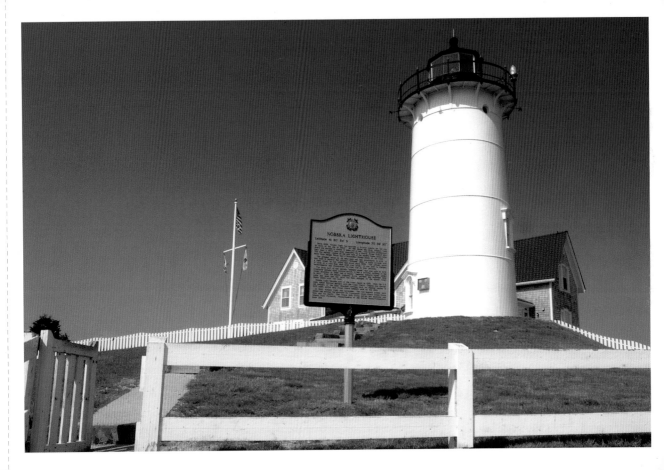

Nobska Light, Woods Hole, Massachu-
setts, established 1828. Nobska Light is
a 40 foot cast iron tower built in 1876. It
is an active light with open grounds and
tours available periodically.

© 2006 Arthur P. Richmond

Published by schifferbooks.com

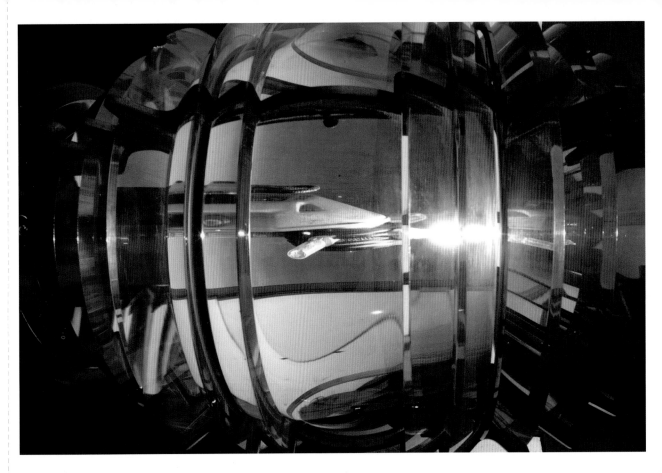

Nobska Light Fresnel lens, Woods Hole, Massachusetts. Automated in 1985, the fourth-order Fresnel lens installed in 1876 remains functional.

© 2006 Arthur P. Richmond

Published by schifferbooks.com

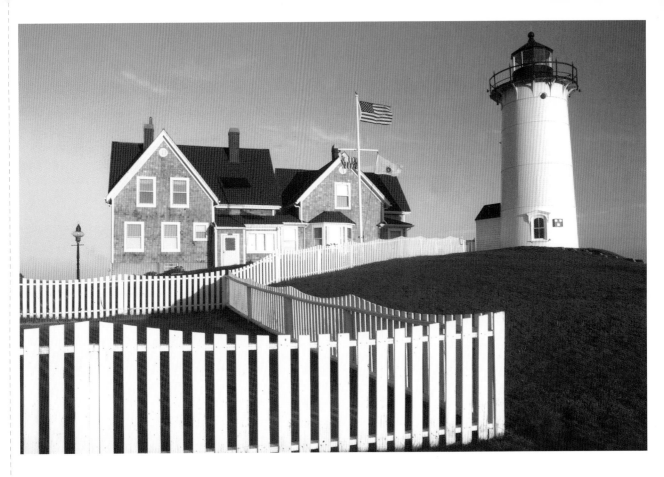

Nobska Light and keeper's house, Wood's
Hole, Massachusetts, established 1828.
The keeper's house is now used as the
residence of the Commander of the
Woods Hole Coast Guard base.

© 2006 Arthur P. Richmond

Published by schifferbooks.com

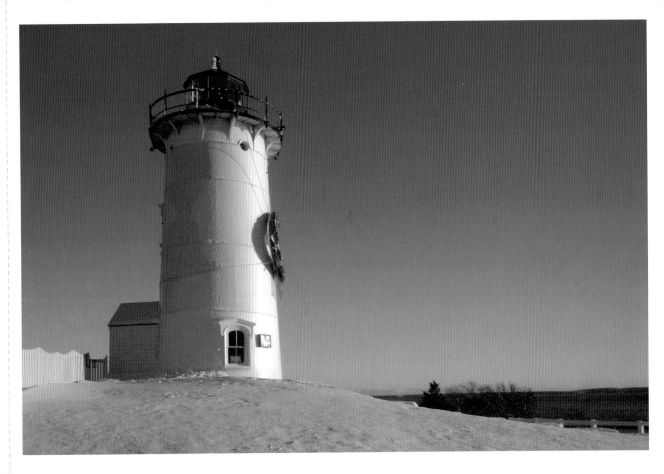

Nobska Light, Woods Hole, Massachusetts, established 1828. The 40 foot tower looks over Vineyard Sound with Martha's Vineyard in the distance.

Published by schifferbooks.com

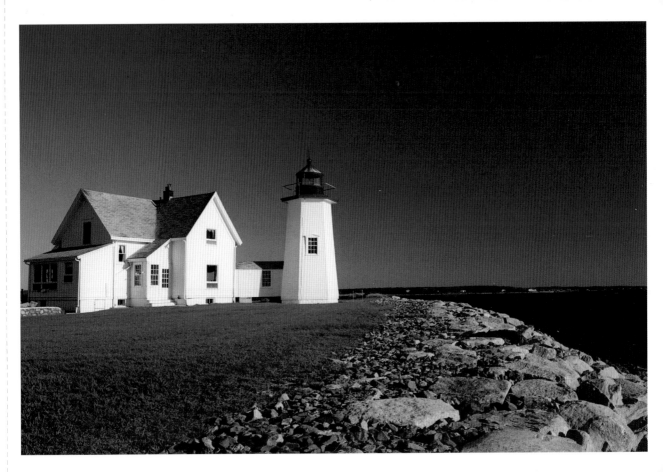

Wings Neck Light, Bourne, Massachusetts, established 1849, deactivated 1945. Built at the entrance to Pocasset Harbor, the light was no longer needed when Cleveland Ledge Light was built in 1941. It is now privately owned.

Published by schifferbooks.com

© 2006 Arthur P. Richmond

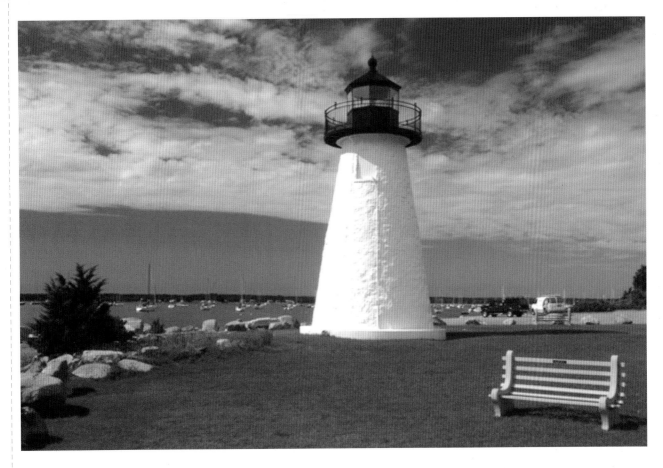

Ned's Point, Mattapoisett, Massachusetts,
established 1837, deactivated 1952,
reactivated 1961. Marking the northwest
side of Buzzard's Bay, Ned's Point Light
is now a town park.

Published by schifferbooks.com

© 2006 Arthur P. Richmond

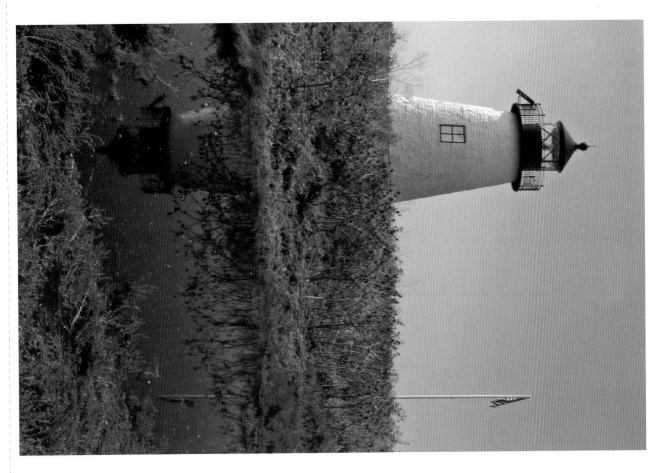

Bird Island Light, Marion, Massachusetts, established 1819, deactivated 1939, reactivated 4 July 1997. On the northwest side of Buzzard's Bay, the light was destroyed by the hurricane of 1930. Volunteers have now restored it as a private aid to navigation.

Published by schifferbooks.com

© 2006 Arthur P. Richmond

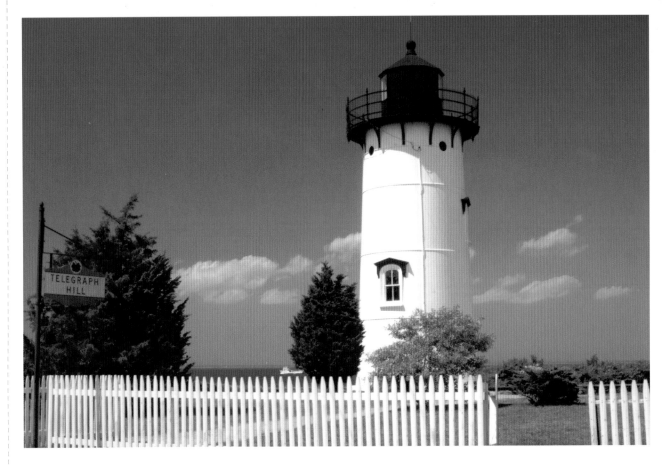

East Chop Light, Oak Bluffs, Martha's Vineyard, Massachusetts, established 1828. Originally privately owned, this light, marking the east side of Vineyard Haven, was taken over by the government in 1878 and automated in 1933. The grounds are open and tours are available periodically.

© 2006 Arthur P. Richmond

Published by schifferbooks.com

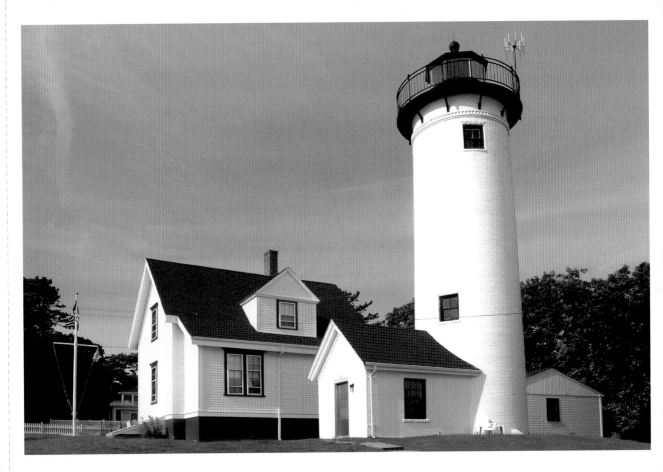

West Chop Light, Vineyard Haven, Martha's Vineyard, Massachusetts, established 1818. The light and keeper's house mark the west side of Vineyard Haven. Built in 1891, the 45 foot tower was automated in 1976 and still has its fourth-order Fresnel lens.

© 2006 Arthur P. Richmond

Published by schifferbooks.com

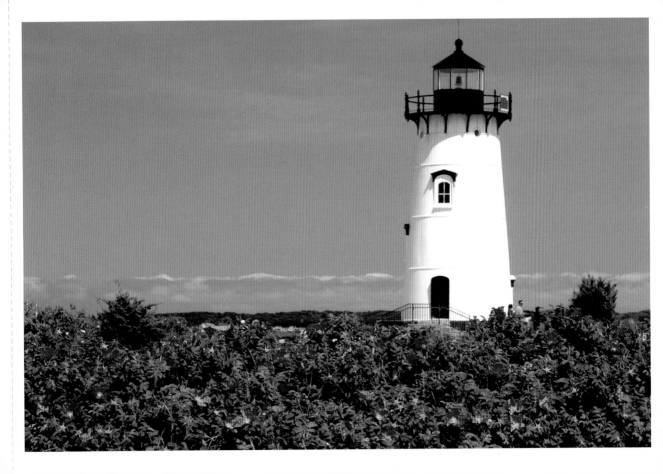

Edgartown Light, Edgartown, Martha's
Vineyard, Massachusetts, established 1828.
Originally offshore and destroyed by the
1938 hurricane, it was replaced by an
abandoned tower from north of Boston.
Automated in 1939, it is open for tours.

Published by schifferbooks.com

© 2006 Arthur P. Richmond

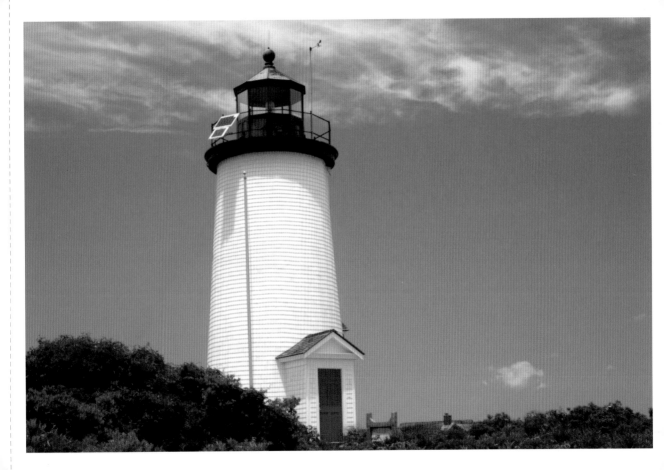

Cape Pogue Light, Chappaquiddick Island, Martha's Vineyard, Massachusetts, established 1801. Replaced twice and moved four times, the light marks the northeast tip of Martha's Vineyard. Automated in 1943, it has been restored and is open for tours.

Published by schifferbooks.com

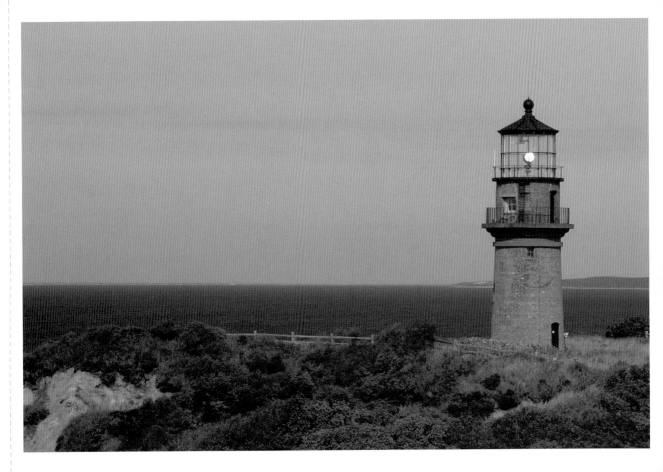

Gay Head Light, Aquinnah, Martha's
Vineyard, Massachusetts, established 1799.
The existing brick tower was built in 1856
and was the first lighthouse in the country
to receive a first-order Fresnel lens. Open
for tours.

© 2006 Arthur P. Richmond

Published by schifferbooks.com

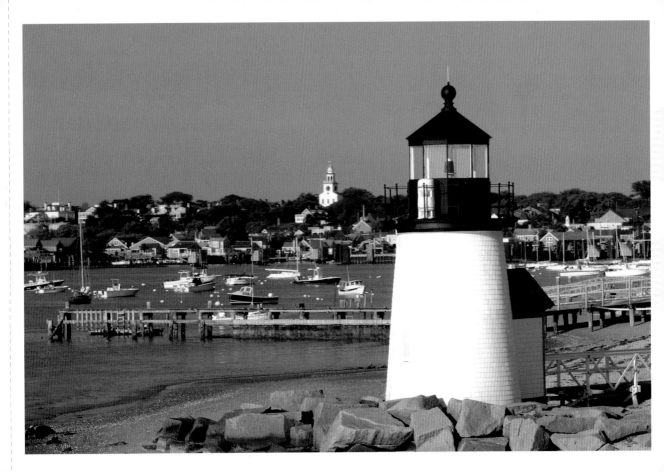

Brant Point Light, Nantucket, Massachusetts, established 1746. The nation's second oldest lighthouse marks the entrance to Nantucket harbor. The 26 foot tower was built in 1901, automated in 1965, and renovated several times.

Published by schifferbooks.com

© 2006 Arthur P. Richmond

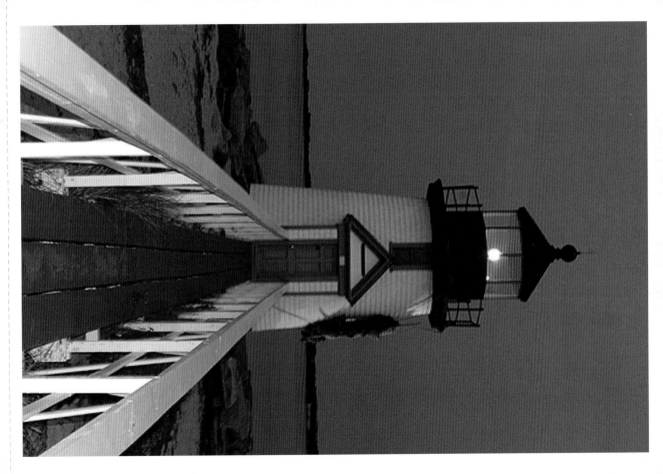

Brant Point Light, Nantucket, Massachusetts. established 1746. The characteristic red light on this 26 foot tower marks the entrance to Nantucket Harbor. The walkway, originally over water, is no longer necessary as the light is now surrounded by sand.

© 2006 Arthur P. Richmond

Published by schifferbooks.com

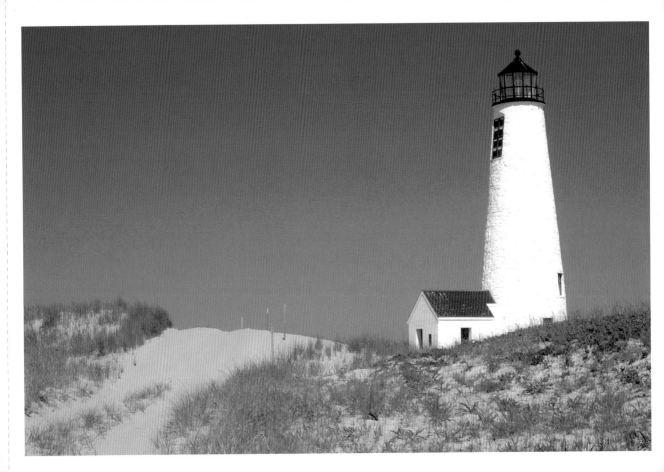

Great Point Light, Nantucket, Massachusetts, established 1784. Located at the northeast tip of Nantucket, the 60 foot tower was rebuilt in 1986 after being destroyed by a storm.

© 2006 Arthur P. Richmond

Published by schifferbooks.com

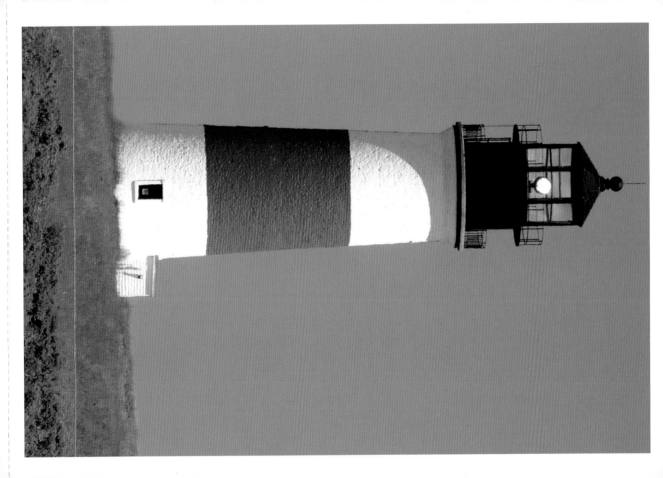

Sankaty Head Light, Nantucket, Massachusetts, established 1850. The 53 foot brick and granite tower with its distinctive white-over-red-over white bands stands on a 90 foot cliff at the southeast corner of Nantucket. It was automated in 1965.

© 2006 Arthur P. Richmond

Published by schifferbooks.com